1 MONTH OF
FREE
READING

at
www.ForgottenBooks.com

By purchasing this book you are eligible for one month membership to ForgottenBooks.com, giving you unlimited access to our entire collection of over 1,000,000 titles via our web site and mobile apps.

To claim your free month visit:
www.forgottenbooks.com/free868595

ISBN 978-0-265-57151-4
PIBN 10868595

This book is a reproduction of an important historical work. Forgotten Books uses
state-of-the-art technology to digitally reconstruct the work, preserving the original format
whilst repairing imperfections present in the aged copy. In rare cases, an imperfection in
the original, such as a blemish or missing page, may be replicated in our edition. We do,
however, repair the vast majority of imperfections successfully; any imperfections that
remain are intentionally left to preserve the state of such historical works.

CATALOGUE

OF THE

ITALIAN PICTURES,

LATELY

BROUGHT FROM ROME,

AND

NOW EXHIBITED IN THE GREAT ROOM,

IN

Whitcomb Street, Leicester Square.

MARCH, 1799.

LONDON:

PRINTED BY G. HAŸDEN, RUSSELL COURT, COVENT GARDEN.

INTRODUCTION.

As some account may be expected to be given of the Pictures contained in this Catalogue, the Proprietor of them takes this opportunity of saying, that they were all collected by him, during a long residence at Rome, from the palaces of many of the first nobility of that city, and the different parts of the Roman state. His situation at Rome, during the troubles which lately agitated that part of Italy, afforded him easy access to the galleries of the nobility, and a confidence with them, which nothing but the disturbed state of the country could have procured him. Profiting by the offers which were made to him, he was enabled to enrich his Collection with many of the finest productions of the greatest masters. It may easily be conceived, that, when the French army was advancing with hasty strides towards Rome, every person who

had

had property to difpofe of was anxious to convert any part of it into the fpecie of the country, where the tranfaction could be done with fecrecy. It is a refpect to his engagements of this nature which alone prevents the Proprietor from publifhing the names of the feveral nobility, whofe galleries have fo liberally contributed to enrich this Collection, and whofe titles would otherwife moft fplendedly ornament the catalogue before us. A

From an unwillingnefs of troubling the reader with a long introduction, we fhall here pafs over the many difficulties which attended the conveying the prefent Collection out of Italy, and the rifk of bringing them into this country. Suffice it, therefore, to fay, that after a nine-weeks paffage they fortunately efcaped every danger, and arrived in London, in their prefent perfect condition; but with an accumulated expence of in-furance, freight, and duties almoft incredible.

The Proprietor confoles himfelf, however, with the reflection, that although his loffes have been great, that his labours have not been wholly thrown away. He

flatters

flatters himself, likewise, that in a country like this, where the Fine Arts are fo liberally patronized, the period will arrive when the prefent Collection will be better known, and valued equal to its merit.

Italy, with concern, be it faid, has been plundered of all its fine ornaments; it will be in vain, therefore, to expect frefh fupplies from that country, nor can the young artifts of the rifing generation be fent there, as formerly, to ftudy the works of the great mafters.

Let a national gallery then of our own be formed, and let us not fubject ourfelves to the humiliating condition of fuing to our rivals, for permiffion to do that which we have the means within ourfelves of accomplifhing;—an undertaking long wifhed for by the moft zealous protecters and real lovers of the arts, and by none more fo than by him, whofe merit has placed him at the head of his profeffion; who has the honour to enjoy the protection and confidence of his fovereign, at the fame time that his private virtues have fecured to him the efteem and refpect of every individual in fociety who has the pleafure of his acquaintance.

With

With his obfervàtion, although, at that time, a perfect ftranger to the Proprietor, we will clofe this Introduction; after a long and attentive examination of the Pictures contained in the enfuing Catalogue, the Prefident of the Royal Academy had the candour and liberality to obferve to the Proprietor, " That he deferved the united thanks of the nation, for having brought into this country fo very valuable a collection! "

CATALOGUE

CATALOGUE

OF

ITALIAN PICTURES, &c.

ROMAN SCHOOL.

RAPHAEL SANTIO DA URBINO,

The Prince of modern Painters, was born at Urbino, in 1483, and died at Rome, in 1520, at the age of 37.

THE NATIVITY OF CHRIST.

ON the fore-ground the Madona and St. Joseph are kneeling, and regarding the Infant with tender and devout expreſſion. He lays along on a piece of linen, ſupported by a little angel; two other little angels ſtanding by, bearing inſtruments of the Paſſion in their hands. Behind is a ruined temple, with an aſs and a cow, of which the

heads

heads only are feen. In the clouds is a group of five little angles, three of whom are chaunting, the others bearing implements of the Paffion. In the middle-ground, which is elevated, are two fhepherds liftening to an angel, who announces to them this event. The diftant view reprefents the town of Bethlehem.

A highly-finifhed cabinet picture, on pannel, perfectly preferved; the tone of colouring clear and warm, efpecially the carnations, which are purely natural.

Size—2 feet 8½ inches high,
 by 2 feet 6¾ inches broad.

PORTRAIT OF BERNARDO DIVIZZIO CARDINAL BIBIENA.

A half-length, books before him, one open in his left hand while his right is employed in writing. He is fhaved, with a ftudious acute phyfiognomy. Through a window appears St. Jerome in a landfchape. The colouring is true to nature, and the whole minutely finifhed. It is impoffible to do juftice to this picture by any defcription.

It is a cabinet jewel of the firft luftre, painted on pannel, and in the higheft ftate of prefervation.

Size—2 feet 7¾ inches high,
 by 2 feet 5¼ inches broad

THE

THE HOLY FAMILY.

The Madona fits upon an elevated bench, with her feet on a ftep. On her left ftands Jofeph in a thoughtful attitude, which is finely expreffed. On the other fide ftands St. John, of an age differently reprefented from that of moft other pictures of this fubject, at leaft twenty-five years of age; his afpect is ferious, and he, as well as Jofeph, regards the fpectator. The attitude of the Virgin is graceful, and her expreffion tender, though not looking at the Child. The Child ftands on her lap, regarding the fpectator with a pleafing fmile.

The figures are the fize of fmall life, about four feet and a half in height—the back ground terminates with a green curtain.

The drawing is correct; the colouring, efpecially the carnations, true and of a warm tone; and the whole is highly finifhed.

This picture was the chief altar-piece of a conventual church in Italy, and was fold to its prefent proprietor under a difpenfation from the Pope, to enable the monks to defray the expence of repairing their church, which had been almoft rent afunder by an earthquake.

B It

It is painted on pannel, well preserved, and has still its ancient coat of varnish on; and is in its original frame, which is a very curious one, having seven subjects of the life of Our Saviour, sketched in colours, on a ground of arabesque, or scroll-work, en grisaille, at equal distances; and in the middle, at bottom, the arms of the town wherein the convent stands.

Size, exclusive of the frame, 5 feet high,
by $4\frac{1}{2}$ feet broad,
And the breadth of the frame $9\frac{1}{2}$ inches.

MADONA AND CHILD, WITH ELIZABETH, &c.

A small highly-finished picture, in water colours, said to have been done by Raphael at sixteen years of age; it came out of the Barberini Palace. The subject is well known by Marc Antonio's print, called *The Madona*, au Berçeau.

FREDERICO BARROCCIO.

Born a Urbino, in 1528, where, after passing a considerable part of his life at Rome and at Florence, he died in 1612, aged 84.

[He drew correctly, was a charming colorist, and gave a pleasing, lively air to his heads.]

MAR-

MARRIAGE OF ST. CATHARINE.

Finely compofed, painted with virgin tints, and frefh as from the eafel. A charming cabinet picture on copper.

Size—22 inches high,
by 18¼ inches wide.

<hr>

FILIPPO LAURI.

Born a Rome, in 1623, where he died in 1694, aged 71.

[Nature, which had not been very favourable to his exterior figure, endowed his mind, in recompence, with the moft valuable qualities. He was a moft excellent fcholar, a charming painter, fkilful in hiftory, in fable, and in perfpective; in his manners he was an ornament to fociety, and a facetious companion.

His drawing is good, his figures graceful, and the ftile of his landfchapes excellent.—His fmall pictures are moft efteemed.]

VENUS AND A SATYR,

Whom a cupid takes by the beard, and is about to peirce with an arrow, while another cupid ties his hands behind; other figures are feen in the back-ground, which is a landfchape richly compofed, with a diftant view of the

fea.

fea. The whole is clear and charmingly painted, with mellow tints, and highly finifhed: the carnations warm and true.—A cabinet piece on cloth.

Size—15¾ inches wide,
by 12¾ inches high.

<hr>

GASPAR POUSSIN.

Born at Rome, in 1613, where he died in 1675, aged 62.

[His furname was Duché, but he affumed that of Pouffin, from his relation to the celebrated Nicolo Pouffin, who married his fifter. The character of his works is fufficently known. He was a man of amiable manners, of a merry humour, generous to his friends, whom he entertained with conviviality.]

A CAPITAL LANDSCHAPE.

Of an oblong form, for a door head, a rich and an extenfive view—fuppofed in the vicinity of Pifa or Lucca.

A DITTO,

Of the fame form and fize. The fore-ground finely diverfified.

They

They are both in his beſt time, and excellently coloured. The figures, which are judiciouſly introduced, are ſuppoſed to be by P. F. Mola.

Size of each—5 feet 7 inches wide,
2 feet 1 inch high.

FLORENTINE

FLORENTINE SCHOOL.

FRANCESCO VANNI, or VANNIUS.

Born at Sienna, in 1563—died in 1609, aged 46.

[He commenced his ftudies at a very early period of life, and after examining and copying the works of the great mafters, he ultimately attached himfelf to the ftiles of Correggio and Barroccio, which he appears to have united in his compofitions. His drawing is correct, his colouring vigorous, with a fweet and tender pencil, which he devoted intirely to fubjects confonant to his religious and moral character. He was created a Knight of the Order of Chrift, by Pope Clement VIII.]

MADONA

MADONA STANDING ON A CRESCENT IN A GLORY OF ANGELS.

SHE is crowned by the Saviour. On one fide ftands an angel, another holds up the drapery of the Virgin. A charming little high finifhed picture on copper.

Size—10¼ inches high,
by 7 inches wide.
It is engraved by Cornelius Galle.

CARLO, OR CARLINO DOLCI.

Born at Florence, in 1616—died in 1686, aged 70.

[He began his ftudies before he was eleven years of age. His pictures, which he finifhed very highly, are chiefly religious fubjects. His drawing is correct, and his colouring very clear and tranfparent; his carnations foft and tender, and feem as if painted on ivory.

ST. CATHARINE.

Large nature—a bright clear picture, the colours frefh as if juft laid on. The expreffion of the faint is fublime. She leans forward on a table, a book in her left hand, her

head

head reclining on her right; an angel is crowing her with flowers. The hands are fine nature.

Size—3 feet 1 inch broad,
by 2 feet 10 inches high.

SCIPIO GAETANO.

Born at Florence, about 1550—*died in* 1588, *aged* 38.

PORTRAIT OF CARDINAL BEMBO.

A buſt—large life—a benign, placid countenance, grey head and beard, painted with great truth of nature, and moſt minutely finiſhed.

Size—19¾ inches high,
by 15¼ inches broad.

LOM-

LOMBARD SCHOOLS.

PARMA.

ANTONIO DE ALLEGRIS, or LIETO;
BETTER KNOWN BY THE NAME OF
CORREGGIO.

The Prince of Grace, Colouring, and Effect.—He was born in 1494, and died in 1534, aged 40.

MADONA AND CHILD, WITH ST. JEROME AND AN ANGEL,

A Graceful and elegant compofition. The colouring is true to nature—clear and tranfparent in the fhades, without the leaft obfcurity.

A charming cabinet jewel, perfectly finifhed.

Size—$16\frac{1}{2}$ inches high,
by 12 inches broad.

C

BAR-

BARTOLOMEO SCHIDONE,

Born at Modena in about 1560, and died at Parma, about the year 1616, aged 56.

[He was educated at the celebrated School of the Carracci, but followed the graceful manner of Correggio.—The rarity of his works is well known.]

MADONA AND CHILD, IN A LANDSCHAPE.

She is wafhing the Child's feet in a brook; the attitude gracefully appropriate, and the landfchape in a great ftile. —A beautiful cabinet piece, on cloth.

Size,—$17\frac{1}{2}$ inches high,
by $13\frac{1}{2}$ broad.

CAV. GIOVANNI LANFRANCO,

Born at Parma in 1581—died at Rome in 1647, aged 76.

[He was a chief fcholar of the Carracci; whom he affifted in their great work, *The Farnefian Gallery*; but he afterwards ftudied the works of Correggio, whofe manner he preferred.]

JUPITER

JUPITER AND EUROPA, JUST LAUNCHED INTO THE SEA.

This picture is poetically compofed. The metamor-phofed King of the Gods is conducted by two little cupids in the air, with ribbons tied to his horns, preceeded by two tritons; a third manages a dolphin, beftrode by a little cupid. The relatives of the lady are feen on the fhore at a diftance in the attitudes of Grief and Defpair. —A capital picture finely coloured.

Size—5 feet wide,
by 4 feet 5 inches high.

LOMBARD

LOMBARD SCHOOLS.

BOLOGNA.

LORENZO SABBATINI.

[Little is known of the life of this excellent artift, only that he appears to have preceded the Carracci; and to have been contemporary with them. His works ought to have infured him more notice from the biographers.]

MADONA AND CHILD, SITTING ON A CRESCENT,

A Charming little picture. She is furrounded with a glory of angels. The colouring bright and tranfparent. —He appears to have been a perfect mafter of the art of forefhortening, of which thofe in this picture are an admirable proof.

Size—15 inches high,
by 13 inches broad.

This Picture is finely engraved by Agoftino Carracci.

THE

THE CARRACCI.

Indignant at the degenerate taſte of their co-temporaries, ſpirited indeed in their execution, but with little regard to nature, they determined to effect a reformation of thoſe corruptions, by the eſtabliſhment of their celebrated academy.

Taking nature and the antique ſtatues for their guide, they rendered themſelves juſtly celebrated for their correctneſs of drawing.

LODOVICO CARRACCI.

Born at Bologna in 1555, where he died in 1619, aged 64.

[Endowed with a rich imagination, he was enabled to treat the ſame ſubject with infinite variety. He was more graceful than his couſin Annibal, and equally correct.]

A PIETA, OR DEAD CHRIST, ON THE LAP OF THE VIRGIN.

A little angel ſtands by in tears. The expreſſion of grief in the Madona is ſublime. The foreſhortenings are

are admirable, and the whole is well defigned, and in an excellent tone of colouring.

Size—5 feet 8 inches high,
by 2 feet broad.

DEAD CHRIST, WITH MARY AND THREE ANGELS,
IN THE ACT OF ADORATION.

A little angel ftands in a penfive attitude. A beautiful, highly finifhed, capital picture. The carnation admirable.

Size—19½ inches wide,
by 16 inches high.

AGOSTINO CARRACCI,

Coufin to Lodovico, was born at Bologna, in 1558, and died at Parma in 1602, aged 44.

[He was a man of polifhed manners, honourable in his dealings, and accomplifhed in all the fciences; in philofophy, the mathematics, poetry, fculpture, &c. and eminent as an engraver.]

POLY-

POLYPHEMUS AND GALATEA.

A capital picture, finely and poetically compofed, and perfectly finifhed, with a rich mellow pencil. The figure of Polyphemus is an admirable fpecimen of correct drawing and relief, and is the celebrated Torfo completed. The elegant and difdainful Galatea and her female attendants are finely contrafted. The landfchape is fingularly beautiful, and extenfively detailed, and reprefents the S. E. coaft of Sicily, with a view of Mount Ætna. The whole is clear, and in the higheft ftate of perfection.

Size—5 feet $7\frac{1}{2}$ inches wide,
by 4 feet 10 inches.

ANNIBAL CARRACCI.

Brother of Agoftino, was born at Bologna, in 1560, and died at Rome, in 1609, aged 49.

[He was an univerfal painter, treating every fubject with equal facility. He drew very correctly, and with great freedom, and every touch is marked with the character of nature, which he affidioufly ftudied as his beft guide. He perfected his ideas by the ftudy of the antique.]

THE

THE REPOSO,

A charming fketch in his Bolognian manner, finely coloured. The head of the fleeping child is admirably painted, on cloth.

Size—13 inches,
by 9 inches.

GUIDO RENI,

One of the moft celebrated artifts of the Bolognian School. He was born at Bologna, in 1575, where he died in 1642, aged 67.

[He was a comely, handfome man, and, while in the School of the Carracci, ferved as a model to Lodovico, when he had occafion to paint angels.

Guido was a charming, graceful painter, particularly in the airs of his heads. His colouring is bright and clear, and his touch extremely delicate and free.

Proud of his art, he would not condefcend to fix the price of his works, but ufually left it to a third perfon.]

THE ANNUNCIATION.

Half figures, the expreffion of both is modeftly devout, the carnations beautifully true. Painted in the manner of

Cara-

Caravaggio, but the fhades tranfparent and free from the darknefs of that mafter.

Size—3 feet 2½ inches wide,
by 2 feet 5 inches high.

ST. JEROME READING IN A LARGE BOOK.

His left hand is held up to his face, as if to fave his eyes. It is painted in a brown warm tone, imitating the ftile of Guercino, and in point of execution' is a *chef d'oeuvre*.—Upright oval.

Size—2 feet 7 inches high,
by 1 foot 11 inches broad.

ST. LUCIA.

A three-quarter fize; rather large life; a clear, warm picture in his beft ftile.

ST. CATHERINE.

An exact companion to the preceding, fimilarly painted. —They are both upon cloth.

Size of each—2 feet 5 inches high,
by 2 feet. 5¼ inches

D BEAUTY

BEAUTY AND LOVE;

OR, PERHAPS,

FORTUNE FLYING OVER THE GLOBE.

They are both naked — a cupid holds her by the hair, while fhe fcatters the contents of her purfe. The figures are large as life; the carnations perfectly true, bright, and tranfparent, poffeffing every quality of his beft works.

It is in the higheft ftate of prefervation; and is infinitely fuperior to the celebrated picture of the fame fubject, lately removed from the Capital at Rome to Paris.

Size—5 feet 3½ inches high,
by 4 feet 3 inches wide.

FRANCESCO ALBANO,

Born at Bologna in 1578, *where he died in* 1660, *aged* 82.

[He was a difciple of the Carracci, and is highly efteemed for his fine colouring, and for the ftile of his landfchapes.]

VENUS

VENUS ATTIRED AFTER BATHING,

An agreeable compofition of nine figures in three groups, beautifully coloured.—Painted on cloth.

Size—2 feet $9\frac{1}{2}$ inches wide,
by 1 foot $6\frac{1}{4}$ inches high.

<hr/>

DOMENICO ZAMPIERI,

DETTO

DOMINICHINO,

One of the beſt diſciples of the Carracci, born at Bologna in 1581, *died in* 1641, *aged* 60.

[He was one of the moſt judicious painters of his own, or any age. He conſidered his ſubject with great attention, before he took up his palette, and always followed nature for his model; taking every opportunity of ſtoring his mind with ſuch characters of the Paſſion as fell under his obſervation, which he ſketched at the moment they occurred, and made uſe of as his ſubjects required them.]

THE STONING OF ST. STEPHEN,

A capital picture, in his beſt time, compoſed with great ſkill. The expreſſion of the Saint is divine; the

action

action of the other figures well contrasted, and the whole
executed with great relief and truth of nature. The
colouring is fine and rich, with broad lights, and good
effect of charo-scuro. In the sky there is a reprefenta-
tion of the Trinity.

Size—5 feet 2 inches broad,
by 3 feet 6½ inches high.

DEATH OF ST. FRANCIS.

He is supported by two angels—a little angel in the
clouds is playing on the violin—finely painted, with a
bright tone of carnation.

Size—3 feet 4½ inches,
by 1 foot 11 inches.

GIOVANNI FRANCESCO BABIERI,

DETTO

GUERCINO DA CENTO,

Born at Cento, near Bologna, in 1590—died in 1666, aged 76.

[He was nick-named Guercino, because he squinted. The genius
of this great artist developed itself at a very early period; for,
when

when only ten years of age, he painted a Madona on the front of his father's houfe, which induced his parents to fend him to Bologna for further improvement. In the fchool of the Carracci he acquired that force of colouring, for which he is fo juftly celebrated. He poffeffed a lively and fruitful imagination with fublime ideas, and a wonderful facility of expreffing them on canvas.

He was at one period captivated with the manner of Carravaggio, and gave great effect to his pictures, by a ftrong contraft of light and fhade, but he knew how to regulate that effect by his fweet and tender pencil. He did not, however, follow that manner long, but forfook it for the more clear, delicate tones of Guido, and ultimately he took nature for his fole director.]

RINALDO AND ARMIDA.

In the poignancy of a finely expreffed grief, fhe is about to plunge an arrow into her breaft, but is prevented by Rinaldo, who feizes the weapon and diverts her from the purpofe by his perfuafive eloquence.

A beautiful, highly finifhed picture—colouring true to nature.

Size—5 feet wide,
by 3 feet 8½ inches high.

ST.

ST. MARGARET,

Half figure—fize of life. She holds up a crofs to the monfter. The carnations warm and true—painted in the manner of Carravaggio, on cloth.

Size—4 feet and half an inch high,
by 3 feet 1 inch wide.

THE HEAD OF A WARRIOR,

Size of life, painted with great force, in the manner of Carravaggio. He aims a ftroke with his fword.— Armour bright and well reprefented. Carnations warm. On cloth.

Size—2 feet 10 inches high,
by 2 feet 6 inches wide.

QUEEN SEMIRAMIS RECEIVING THE NEWS OF THE DEFEAT OF HER ARMY.

She is fitting at her toilet, with a calm and dignified expreffion of grief, in which her domeftic fympathifes. A highly finifhed, clear picture, in his beft ftile. The car-
nations

nations warm and admirably true, and the fhades clear and tranfparent.

Size—$5\frac{1}{4}$ feet wide,
by 4 feet and half an inch high.

This picture has been engraved.

MOSES, WITH THE TABLES OF THE LAW,

Half figure—countenance majeftic, with a long white beard. Finely coloured and highly finifhed.

Size—3 feet $10\frac{1}{2}$ inches high,
by 3 feet 5 inches wide.

LOT AND HIS DAUGHTERS,

One of the moft capital Pictures of this great Mafter, and to which it is impoffible to do juftice by any defcription.

The fubject is treated with the utmoft delicacy; the drawing extremely correct; the touch fpirited; and the whole clear and tranfparent.—It is highly finifhed, *and the colouring* NATURE ITSELF.

Painted on cloth.

Size—7 feet 8 inches wide,
by 5 feet 10 inches high.

LUCRETIA.

LUCRETIA.

Half figure; fize of life; expreffion dignified and ap-
propriate; tone of colouring warm. Admirably painted
in his beft time.

Size—2 feet 9¾ inches high,
by 2 feet 5½ inches.

DRAWINGS.

ABIGAIL MEETING DAVID;

A rich and elegant compofition, of about fourteen
figures, vigoroufly executed in biftre, with infinite fpirit
and determined fkill. The figures are about fifteen
inches in height, finely drawn, and characterized in the
beft time of the mafter.

This is certainly the moft capital drawing of Guercino
in England, or, perhaps, in the world.—Framed, with
plate glafs.

Size—2 feet 6½ inches wide,
by 2 feet 1 inch high.

ST.

DRAWINGS.

ST. CECILIA PLAYING ON THE ORGAN,

A charming defign, in biftre; the hands fine and graceful. It is in a curious, antient frame.

THE HEAD OF A WARRIOR.

He is in an helmet, adorned with plumage, in pen and biftre; below is the following infcription:

" *D'ogni dio fpezzatore e chi repone ne la fpada, fua legge*
" *e fua Raggione.*"

A mafterly drawing, and the ftudy for the picture in page 30.

JOSEPH AND CHILD,

A graceful defign, in red chalk.

SUSANNAH AND THE ELDERS,

A capital defign, in red chalk, ftumped. The characters and expreffion appropriate.

E BENE-

BENEDETTO -GENNARI,

The nephew and difciple of Guercino, was born in 1633, *and died in* 1715, *aged* 82.

[By affifting his uncle in his great works he acquired that excellence of colouring for which Guercino is fo juftly celebrated. He came over to England, and was employed by King Charles II.]

MARY MAGDALEN, NAKED TO THE MIDDLE.

She is laying along on the ground under a rock, with a death's head and other fymbols of her repentance. She fupports her head on her right arm, with an elegant expreffion of penfive forrow. A clear picture, finely painted, and highly finifhed.

Size—5 feet wide,
 by 3 feet 11 inches high.

IPPOLITO SCARSELLINO DA FERRARA.

[The fon of Sigifmunda Scarcella, an excellent defigner, and fkilful architect, from whom he received his firft leffons. He was afterwards fent to Venice and Bologna, from whence he returned home a fkilful proficient. He had a fruitful invention and a charmingly delicate pencil.—He died in 1620.]

CHRIST'S

CHRIST'S ENTRY INTO JERUSALEM.

The meek and divine character of Our Saviour, and the action and devout attitudes of the multitude are finely conceived. A beautiful cabinet picture, in the Venetian ftile of colouring. Painted on copper, and highly finifhed.

Size—16 inches wide,
by $11\frac{1}{2}$ inches high.

CHRIST PRAYING IN THE GARDEN.

The fubject is evening, and the figures are illuminated by the angel that prefents the cup. The characters of the fleeping apoftles are finely expreffed.

This picture is a companion to the above, and in the fame ftile.

The landfchape in both is in a great manner, and well kept.

VENETIAN

VENETIAN SCHOOL.

∗ ⟩━━━━⟫·✵·⟪━━━━⟨ ∗

TIZIANO VECELLI DA CADORE, TITIAN,

Born at Cadore, in the Frioul, in 1477—died of the Plague, in 1576, aged 99.

MADONA, WITH ST. JOHN BAPTIST, AND THREE OTHER SAINTS.

SHE is fuckling the child. The back-ground is a land-fchape, of which but little is feen. Colouring warm, and highly finifhed in his beft ftile. The figures are about eighteen inches.—A cabinet picture, on cloth.

Size—3 feet 1 inch wide,
by 2 feet 1¼ inch high.

PORTRAIT

PORTRAIT OF POPE CLEMENT VIII.

Half length; fitting in a chair; highly finifhed in his beft time.

Size—4 feet 3½ inches high,
by 2 feet 2½ inches.

" Pope Clement VIII. (Julius de Medicis) fucceed-
" ed Adrian VII. in 1523. Rome was plundered during
" his pontificate, by the Connetable de Bourbon ;—
" and it was he who refufed to grant a bull to King
" Henry VIII. of England for the marriage of Anna
" Bolen."

PORTRAIT OF POPE PAUL III.

Half length; fitting in a chair; an auftere, monaftic character of an old man with a white beard, inclining to yellow, highly finifhed.

Size—3 feet 10 inches high,
by 3 feet and half an inch.

" This Pontiff (Alexander Farnefe) fucceeded Clement
" VIII. in 1534, during the reign of Francis I. and
" Charles

" Charles V. He eſtabliſhed the Inquiſition, and ap-
" proved the ſociety of Jeſuits. He acted with great
" rigour towards King Henry VIII. and by that means
" finiſhed what Clement VIII. had begun, the loſs of
" the papal authority in England.

" He died in 1549, aged 82. He was a man of letters,
" of great talents, humane in his manners, and of noble
" ſentiment."

GIACOMO DA PONTE BASSANO,

Born in 1510, at Baſſano, where he died in 1592, aged 82.

ST. JEROME IN A LANDSCHAPE.

The expreſſion of the Saint is fervently devout. The
lion is uſually at reſt in repreſentations of this ſaint, but
here he appears to be roaring. A ſpirited little picture,
on cloth.

Size—2 feet 1 inch wide.
by 1 foot 7¾ inches high.

GIACOMO

GIACOMO ROBUSTI,
DETTO
TINTORETTO,

Born at Venice, in 1512, where he died in 1594, aged 82.

[He was a difciple of Titian, who, jealous of his promifing talents, took an opportunity of difmiffing him from his fchool. He had an extremely fruitful invention, and delivered his ideas to the canvas with fuch facility and promptitude, without making any previous defign, as to obtain the appellation of the furious Tintoretto.]

ST. SEBASTIAN, WITH AN ANGEL PULLING AN ARROW OUT OF HIS SIDE.

The Saint appears to be in a fwoon. The defign is fine and correct; the carnations warm and natural; and the whole a mafter-piece of colouring. A cabinet picture, by many fuppofed to be of Tititan.

Size—2 feet 11 inches wide,
by 2 feet 4¼ high.

THE ADORATION OF THE MAGI,

A rich and moft capital compofition of nine figures. The back-ground is a landfchape. The colouring is warm and

and mellow, and the penciling free and broad, with a great effect. Painted on cloth.

Size—6 feet 1 inch wide,
by 6 feet high.

N. B. The head of the European monarch is a portrait of the Emperor Charles V.

PAOLO CALLIARI VERONESE,

Was born, at Verona, in 1532, *and died at Venice in* 1588.

[He composed with great skill, with grace and variety in the airs of his heads, giving a good effect to the *tout ensemble*. His carnations warm, transparent, and true to nature; and his colouring fresh and lively, from the use of virgin tints, which he placed with great judgment.]

THE MARRIAGE OF ST. CATHARINE.

Half figures—a fine, clear picture, highly finished, with a light, free touch. The effect is good, and the colouring warm. It is painted on cloth, and much in the stile of Titian.

Size—3 feet,
by 2 feet 8 inches high.

GIACOMO

GIACOMO PALMA VECCHIO,

Born at Sermoleta, in the territory of Bergamo, in 1540—died at Venice, in 1588, aged 48. He was a disciple of Titian.

CUPID AND PSYCHÉ.

She is just going to 'waken from a pleasant dream, at the touch of Cupid, who is on the wing. The carnations are warm and true. The back-ground is a landschape. A charming cabinet picture, on cloth.

Size—19 inches wide,
by 15½ inches high.

GIACOMO PALMA GIOVANNI,

Nephew of the preceding Artist, born at Venice, in 1544, where he died, in 1628, aged 84.

SUSANNAH AND THE ELDERS,

An excellent little picture, highly finished, with a light touch; correctly drawn, finely composed, and well coloured. Painted on cloth.

Size—11½ inches high,
by 14¼ inches wide.

F NEAPOLITAN

NEAPOLITAN SCHOOL.

SALVATOR ROSA,

Born at Naples, in 1615—died at Rome, in 1673, aged 58.

A LANDSCHAPE,—A WOOD SCENE,

A Singular compofition of this mafter, having much of the manner and effect of Jacob Ruyfdaal; painted with his ufual freedom and touch. On the left are three banditti, with other figures, at a diftance.

Size—4 feet 5½ inches wide,
by 3 feet 2½ inches high.

AN

AN UPRIGHT LANDSCHAPE, WITH LARGE TRUNKS OF TREES,

A mafterly fketch; warm and mellow tone of colouring. A faint is reading in a book on the fore-ground.—Painted on cloth.

Size—2 feet 2 inches high,
by 16½ inches wide.

AN INTERESTING LANDSCHAPE,

Painted in the bold and ftriking manner of this extraordinary painter, and in his beft ftile.—The fore-ground confifts of woods, mountains and rocks, with feveral figures varioufly and actively employed; with a perfpective of a river with boats, &c. Beyond thefe are feen buildings and aqueducts, bounded by mountains, characteriftic of the fcenery of the country, whence the fineft pieces of this great mafter were chiefly drawn.

Size—4 feet 5 inches long,
by 2 feet 5 inches high.

F 2 SPANISH

SPANISH SCHOOL.

DON DIEGO VELASQUEZ DE SILVA.

Born at Seville, in 1594—died at Madrid in 1660.

[He was at firſt an univerſal painter, but afterwards contracted his practice to hiſtory and portrait. He ſtudied the Belles Lettres, and every thing that could enrich his imagination, and mature his judgment, with unremitting aſſiduity.

He was one of the greateſt painters that ever exiſted. His hiſtorical compoſitions are learned, and painted with great harmony and force; and his portraits, beſides their ſtriking reſemblance, appear animated with the very ſouls of the perſons repreſented.

In

In what estimation he was held, in his native country, may be conceived, from his being promoted to the rank of nobility, and appointed to offices of dignity in the state.

A good account of him is to be found in Cumberland's Lives of the Spaniſh Painters; but the two ſpecimens of work in this collection will better explain his merits.]

THE ECCE HOMO.

Chriſt, with a character inexpreſſibly meek, is expoſed naked to the people. Pilate, who is habited in the jewiſh cuſtumé, with not a little of the characteriſtic of that nation, has that expreſſion which may be conceived from his words on the occaſion. His appearance is dignified. The ſoldier, who ſtands on the other ſide, is brutal licentiouſneſs itſelf, *and wears the bonet rouge.*

The carnations are natural and appropriate. It is painted with a rich body of colour, with a large and free touch; and is altogether a maſter-piece of genius and art.

Size—3 feet 11 inches high,
by 3 feet 1½ inches wide.

PORTRAIT OF POPE INNOCENT X.

To whom Velaſquez was ſent on an embaſſy by his court. The family name of this Pontiff was Jo. Bapt. Pamphili.

Pamphili. He fucceeded Urban VIII. in 1644, at the age of 72, and died on the 6th of January, 1655, aged 81.

No defcription can do juftice to this picture. It is a buft, large as life, wonderfully expreffive, and a mafter-piece of art, being painted with as few touches as poffible. This picture is mentioned in his life by Cumberland.—On cloth.

Size—25 inches high,
by 19½ inches.

FRENCH

FRENCH SCHOOL.

NICOLO POUSSIN,

*Born at Andely, in Normandy, in 1594—died in 1665, aged 71,
but studied mostly in Italy.*

A MOUNTAINOUS LANDSCHAPE,

IN his usual great stile. In the middle-ground there is a lake, and on the left side, near the fore-ground, a water-fall. A man on the fore-ground is walking with his dog, whilst another, at some distance, is driving a flock of sheep.

Size—5 feet 7 inches,
by 3 feet 2 inches.

JACOMO

JACOMO CALLOT,

Born at Nancy, in Lorraine, in 1593—*died in* 1635.

A PAIR OF MERRY-MAKINGS.

Each containing an infinite number of fmall figures; fome on horfe-back, others in carriages, all running the race of pleafure. The fcene is a great fquare, or wide ftreet,—the figures are grouped in his ufual incomparable manner,—the keeping admirable, and the colour of the whole lively, and in perfect harmony.

Size—2 feet 8 inches wide,
by 1 foot 8½ inches high.

PAIR OF SEA-PORTS,

Suppofed to be Spanifh. The fcenes of the fame gaiety as the preceding pair, though the figures are not fo numerous. There are feveral tilted boats, but no fhipping. The buildings are elegant, and the colouring and degradations as in the two preceding; and they are of the fame fize.

The pictures of Callot are extremely rare.

DUTCH

DUTCH MASTERS.

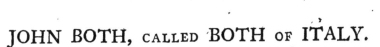

JOHN BOTH, CALLED BOTH OF ITALY.

A LANDSCAPE,

A Morning fcene in Italy, in a great ftile. On the fore-ground, towards the left, is a large clump of trees; farther off, towards the middle, is a lake, on the fide of which appears a fkirmifh between light horfe; and on the fore-ground are other equeftrians in the fury of purfuit. The horfes, as well as their riders, full of animation, are painted by PETER DE LAER, nick-named BAM_BOCCIO.

Size—5 feet 6¼ inches broad,
by 4 feet high.

G A DITTO

A DITTO,

A warm evening fcene, much in the ftile of Claude.
It is bounded by large trees on each fide, with a lake and
figures at a diftance, and is enriched with a ftag-hunt on
the fore-ground. The figures by the fame artift, P. DE
LAER.

Size nearly the fame as the foregoing.

VARIA.

VARIA.

MADONA AND CHILD,

A Highly-finiſhed, ſmall cabinet picture, finely drawn and coloured, ſuppoſed to be an early performance of LEONARDO DA VINCI—perhaps rather by his maſter ANDREA VERROCCHIO.

Size—12½ inches high,
by 10¾ wide.

CUPID DRAWING HIS BOW,

An elegant and finely drawn figure—fine expreſſion, ſaid to be by CAVALIER JOSEPH D'ARPINO—perhaps by JULIUS CÆSAR PROCACCINO.

Size—10½ inches high,
by 7½ inch wide.

A D D E N D A.

NEAPOLITAN SCHOOL.

CAVALIER JOSEPPE D'ARPINO,

Was born near Naples, in 1560—died at Rome, in 1640, aged 80.

THE FOUR EVANGELISTS,
[*In two Pictures.*]

THEY are only bufts with hands, above twice the fize of life, being intended to be placed at a great height.— They are paintd in a grand ftile, and are admirable in their kind.

Size of each picture—3 feet 16 inches wide, by 3 feet high.

H

A GIPSEY

A GIPSEY FAMILY,

On the fore-ground of a landfcape, by LOCATELLI, fweetly painted. A circle of $3\frac{1}{2}$ inches diameter.

FLEMISH SCHOOL.

SIR ANTHONY VANDYCK,

[Too well known in this country to require any account of him.]

THE DUC DE MONCADA,

A very fine copy of the celebrated Equeſtrian Portrait, done in Italy. He is mounted on the famous white horfe on which Charles I. is reprefented.

Size—$9\frac{1}{2}$ feet by 5 feet.

This piɛture is engraved by Morghan.

ROMAN

ROMAN SCHOOL.

———

CARLO MARATTI,

Born in the Marche of Ancona, in 1625—died in 1713, aged 88.

[He was an excellent painter, learned in hiftory and allegory. He compofed well, and painted with great freedom, and a frefh and mellow pencil.]

THE DEATH OF JOSEPH.

He is juft expiring; Chrift and the Madona are on different fides of the bed, at the foot of which, on the right, the angel Gabriel is kneeling, and two little angels are judicioufly placed on the fore-ground to break the line of the bed. The fubject is illuminated by the Holy Ghoft, in a glory of angels. A fine, bright picture, on cloth. Upright.

Size—4 feet 5 inches,
by 3 feet 2½ inches.

FLORENTINE

FLORENTINE SCHOOL.

◄═══╼▪▪╾═══►

LEONARDO DA VINCI,

Born in 1455, *of noble birth, died, in the arms of Francis* I. *in* 1530, *aged* 75.

[He was an artift of univerfal talents, and the different works which he has left behind him have ferved as unerring guides to pofterity.]

A LADY'S HEAD,

[*Three Quarters,*]

A warm and clear portrait, on pannel, minutely finifhed. Small cabinet picture.

Size—17¼ inches upright,
by 13½ inches,

VENETIAN

VENETIAN SCHOOL.

TIZIANO VECELLI DA CADORE, TITIAN.

THE HOLY FAMILY.

The Madona supports the infant on her lap, whilst St. Catharine, on the left, kneels respectfully and in the most graceful attitude, to receive him; St. Joseph is on the right of the Virgin, devoutly reclining on his staff, in seeming devout meditation.

The figures are nearly as large as life, in the centre of the picture, near a magnificent ruin, in a rich and beautiful country; interestingly ornamented with wood, mountains, and vale, and intersperfed with buildings and cattle.— The whole forms a grand and captivating view; and prefents to the obferver, perhaps, as fine a picture as ever was painted by this great mafter! for it is difficult to decide whether you are moft pleafed with the mafterly

<div align="right">grouping</div>

grouping of the figures, or the rich beauties of the land-
fcape; with the eafy elegance of the attitudes, or the
fine glow of colour which warms and animates the whole
compofition.

Size, without the frame—4 feet 5 inches high,
by 5 feet 8½ inches long.

DOMENICO CAMPAGNOLA.

[This artift, though an incomparable landfcape painter, is not
noticed by the biographers, of courfe we know nothing of his
hiftory.]

A CAPITAL ITALIAN LANDSCAPE,

The ftile is great; it reprefents an arm of the fea,
bounded on the fore-ground by land on each fide; on the
right appears a romantic, natural arch, of great fize.—
Figures on the fore-ground.

A CAPITAL DITTO,

In a fimilar character; romantic, excavated rocks on
the right fide, with a mountainous diftant view. Figures,
boats, &c.

N. B. Both thefe pictures reprefent parts of the coaft
of Genoa.

A CAP-

A CAPITAL ITALIAN LANDSCAPE,

An interior fcene; the ground romantically broken with buildings. A deep river traverfes it obliquely, on which is a boat, with two figures.

A DITTO,

Seemingly a different view of the fame river. The aerial perfpective is excellent in all thefe landfcapes; the effect great, and the colouring harmonious.

Size of each—6 feet 11 inches,
by 2 feet 1 inch.

FINIS.

CPSIA information can be obtained
at www.ICGtesting.com
Printed in the USA
BVHW040855180219
540528BV00005B/61/P